Drawing for Beginners to Experts

How to Draw Comics

Andrew Harnes

© 2017

©Copyright 2017

All rights reserved. No portion of this book may be reproduced - mechanically, electronically, or by any other means, including photocopying- without the permission of the publisher.

Disclaimer

All rights reserved. No part of this publication may be reproduced, distributed, or transmitted in any form or by any means, including photocopying, recording, or other electronic or mechanical methods, without the prior written permission of the publisher, except in the case of brief quotations embodied in critical reviews and certain other noncommercial uses permitted by copyright law. The information provided in this book is designed to provide helpful information on the subjects discussed. The author's books are only meant to provide the reader with the basics knowledge of the topic in question, without any warranties regarding whether the reader will, or will not, be able to incorporate and apply all the information provided. Although the writer will make his best effort share her insights, the topic in question is a complex one, and each person needs a different timeframe to fully incorporate new information. Neither this book, nor any of the author's books constitute a promise that the reader will learn anything within a certain timeframe.

Table of Contents

Introduction ... 4
 Basic Shapes .. 5
 Breaking down Objects 7
Body Structure .. 11
 Female Figures ... 11
 Differences ... 14
 Proportions .. 17
 Hands .. 20
 Heads .. 25
 Expressions .. 30
Posing ... 33
 Foreshortening .. 33
 Poses ... 36
Adding Clothes ... 39
Inking and Coloring ... 42
 Inking .. 42
 Coloring .. 44
Conclusion .. 46

Introduction

Some people consider the female character to be hard to draw because of their body proportions that throw the balance off. When you break a female character down though, it becomes considerably less difficult to draw and you develop a deeper understanding of what goes into a woman and her anatomy. A lot of the things that we'll be covering in here can also be applied to male figures and other complex objects, like breaking them down into simpler objects and how to place them so that they have a foreground and a background while looking completely realistic.

This book, although focusing on digitally drawn characters, applies to characters drawn with paper and pencil or in almost any medium that exists. Doodling the parts of the characters that help you to create and establish character proportions and divisions can aid in your overall drawing as the instincts to spot issues in your female characters gets sharper. But the only way you can really develop these instincts is to practice drawing constantly and work on the bones of characters before working on their full figures and characteristics. It doesn't matter how you practice or where you practice, you just need to do it. This book will give you the bones of how to practice and where to devote your time, but it won't do much for you if you don't practice.

We're going to start by breaking down complex shapes to create female figures using the simple shapes to create something more manageable. You'll see the female figures aren't as complicated as a lot of people say that they are.

Basic Shapes

Before building up a character of any type from scratch, you need to be able to see and understand how the most basic of shapes can fit together to make something considerably more complex. A human figure is just a number of basic shapes manipulated and put together in order to make it recognizable to other people.

Basic Shapes

Figure 1 shows a number of generic shapes that a number of people cover when they are extremely young. You can see them in both 2D and 3D because both of them are used in the creation of characters. When you go to break up a character, you'll look for shapes like these (or some that aren't pictured) to establish how the character or object fits together. And these shapes don't remain as simple as square as you see them in figure 1, a lot of pieces can move around and be manipulated into leaning one way or the other as your character or object moves and shifts.

Let's take a look at figure 2 for an example. You can see the outline of a teddy bear broken down into simpler shapes. The body is made up of an egg-shaped oval, and coming off of it is an uneven circle to make up the head, with two egg-shaped oval ears at the top. The legs are cylinders that are chopped up to fit the 3D body shape

and fit onto the ovular feet. When you look at the arms, you see that some of the shapes that we've been discussing have to be manipulated into almost unrecognizable shapes. These arms look a little bit like circular cylinder with soft ends and bends in the middle. All of these shapes make up the shadow of a teddy bear, but you see how a complicated object has been broken down into smaller pieces

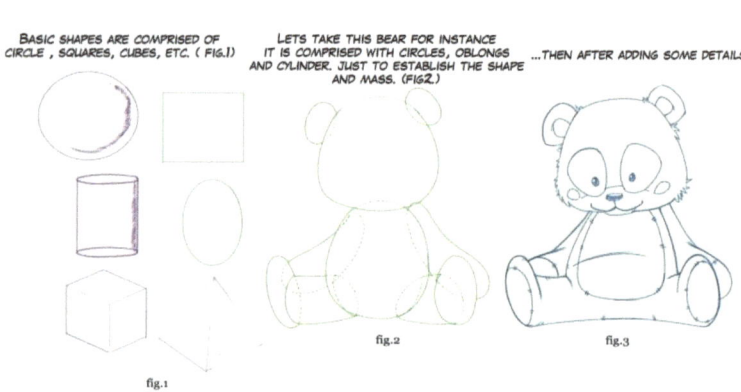

and becomes something manageable.

Now that you have a better understanding of how to break down a figure, let's see what happens when you build it back up, like in figure 3. Figure 2 has been smoothed out and the shapes have been manipulated a little bit, but the overall shapes that we discussed remain the same. We also add even more shapes to the bear for details that don't exist in figure 2. For example, the bear's egg-shaped tummy now has an egg-shaped oval to follow the original shape and make a little bit of difference and put some depth on it. The legs are still cylinders and the feet also have that ovular shape, but the feet have another oval on the bottom of them, once again

adding depth and showing a difference. The arms retain their odd cylindrical shape and have a small circle at the bottom, showing the end of the sphere, if they may look like odd circles. However, a majority of the details are in the face. The eyes and nose are ovals, while the cheeks and areas around the eyes are upside-down eggs that look to add some life to the teddy bear. Finally, there's a small cut out around the inside of the ear to add depth and define what would be the inside of the ear.

Complex objects and simple shapes are everywhere. Once you train yourself to see them, objects that you may have previously considered to be out of your skill set can suddenly become attainable. All of the shapes that we've covered have been things that a lot of people learn about before they're even in school. In the next section of this chapter, we'll be spending more time working on how to break down objects.

Exercise: Look at objects around your house. Pick a couple of them to break down and try drawing, using the simple shapes that we covered in this chapter. All you need to do is match figure 2 in the example to understand the general shape of the object. If you would like to move on to matching figure 3, feel free to try it. Pick at least one new object to try simplifying every day.

Breaking down Objects

Now that we've discussed the simple shapes that make up

objects, we're going to see how these simpler shapes can be put together in order to make complicated objects more manageable. Like we did with the teddy bear, we'll be looking at everyday objects to help explain this concept.

Figure 1 shows a stapler, the full shape of which can be seen in the image on the far left. Note that there are three major portions of the staple, the bottom, the top, and the stapler holder in silver hanging down from the top. Now that we've identified all of the parts that make up the stapler, we can start breaking it down into its individual portions in simple shapes. The bottom of the stapler (marked with green) is pretty much a rectangle running the length of the object. For now, ignore the soft corners that the stapler has at the front, we're just going to cover the overall shape. The stapler holder (marked with red) is a very straightforward 3D rectangle that fits into the top of the stapler (marked with blue) that's a slightly curved rectangle at the front and a cube at the back. In the image on the far right of figure 1, you can see the shape of the stapler from the middle image all smoothed out. Notice how the image on the far right and the original stapler look alike, the corners of the actual stapler are smoother than the drawing, but you see how breaking down the stapler has produced something that look extremely similar to the original.

Now we'll talk about a shape that's slightly more complicated because it's see through. Look at figure 2. The shape of

BREAKING THINGS INTO BASIC SHAPES

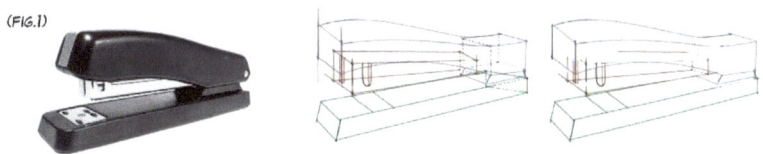

the wine bottle is simpler than that of the stapler in figure 1, but it's more complicated because the shapes that we'll be using don't actually touch each other. In the original image on the left side, you can see everything in the bottle, including the bottom bump that goes up into the bottle. For now, you'll want to ignore that bump as we simplify the bottle into two separate cylinders. The first cylinder (marked with red) takes up the bottom of the bottle, it is the same width as the bottle and goes all the way up the bottom of the bottle until the bottle's shoulders begin to slope inwards. The second cylinder (marked with blue) is significantly narrower than the base and follows the width of the neck of the bottle. It descends down into the shoulders, but maintains the same shape all the way down, stopping just above the larger cylinder. The shoulders of the bottle simply slope down from the neck of the bottle to the shoulders. Everything from the center image has been smoothed out in the right hand bottle and the bottom bump has been restored to its place. Now, this isn't the only way to break down a bottle, you may have another way to break it down and draw it, and that's fine. Every person sees

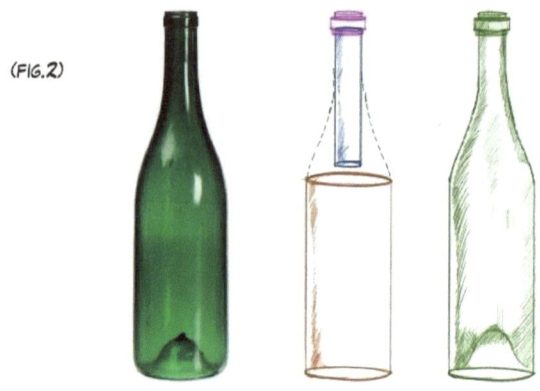

(FIG.2)

the world in a different way.

In this chapter, you have seen that breaking down objects allows something complicated to become simple. Replicating a complex object, as seen with the stapler in figure 1, becomes easy when it's broken down. The bottle from figure 2, although looking simpler than the stapler, can still be broken down even more and fleshed out. With the basics covered, we can now move on to female figures.

Exercise: Pick a complex object either inside or outside and break it down like we've been talking about. Then, draw them, using the examples of the stapler and the wine bottle to guide you. See how the objects fit together and make sure that you can see all parts of the shapes before erasing them. Compare your drawing to the original object and see how close you came to replicating it. Practice this every day.

Body Structure

Men and women tend to have completely different body structures when you compare the two side by side. Some of the differences are blatantly obvious (like women having breasts and men not) but others may be harder to spot and pick up on. The structure of the body will also tell the viewer something about your character, like whether or not they work out or how they take care of their body. Knowing your anatomy to create a body structure is extremely important, so spend some time reading a book, researching on the net, or a combination of both. A common recommendation for people to use as a reference for drawing humans is *Figure Drawing*, by Andrew Loomis.

Female Figures

Many people are wary of women's figures because they can be hard to draw properly. In a most basic sense, a female figure tends to be curvy, like an hour glass or a figure eight, with the center portion of those descriptions showing where the waist is.

Let's look at figure 1 for a better idea how of how curves lay on a woman's body. As you look at the purple arrows, you can see how the curves move with the woman's body in a posed position. Because of the pose, the most prominent curve is the figure's right hip and you can see how the curve of the body starts at the hip and

moves down the leg, curving it at the disconnected portion of the body where the waist would be. On the figure 1's left side, you have a slightly better idea of how curves can really work on a woman. The top arrow flows down from the under arm to the waist, marking where the waist is on the elongated side that may actually hide the waistline. The next arrow shows where the hip is, starting at the waist and marking where the top of the woman's leg is. On the right side, that curve was hidden because of the figure's pose. The final arrow moves down and shows the curve of the thigh, something that is seamless on the other side of the figure. The number of curves seem intimidating, but let's break the figure down a little bit more.

Figure 2 and the other small figures below show the figure eight shape that we were discussing earlier. It highlights a woman's figure and tends to be simpler to draw than that of an hourglass. Please note that women's waists aren't actually that in, we're merely using it to emphasize a shape that a number of women already have and it's easily manipulated to be either top or bottom heavy, which women can be. Let's take a closer look at figure 2 and where the limbs fall on the body. For starters, the arms come off at the widest point of the figure eight, which show where the shoulders are. The legs come off the widest part of the lower part of the figure eight, notice how the figure's right leg follows the curve of the waist before coming down, this gives the smooth curve that we were discussing on the same side in figure 1. In the three lower drawings of figure 2, you can see how the figure eight shape really shows the

curves in various poses that a women can be in. A common walking pose can highlights the hips of a woman while she moves as the hips sway and are emphasized in the way that she moves. When a woman is standing, her legs rest right under the hips, giving her very smooth curves that go from the chest to the legs, no curve in particular is emphasized as you look down the body. When a woman is in a running or leaping motion, the curves from the chest to the hips are extremely smooth before being abruptly broken at the legs as they move.

On the right side of the image, you can see a fully fleshed out woman from figures 1 and 2. The smooth curves that we've been discussing on the right side of the body can be seen underneath the belts and gear on her hips. On her left side, you can see that the waist curve has been elongated and is almost invisible, it's marked by the gear on her hips. The rest of the curves that we've been discussing are hidden under her half-skirt.

Exercise: Practice drawing the figure eight women from figure two. Start by drawing a simple figure eight woman in various positions until you have it mastered and can see the curves developing. Once you feel comfortable with that, start observing women around you

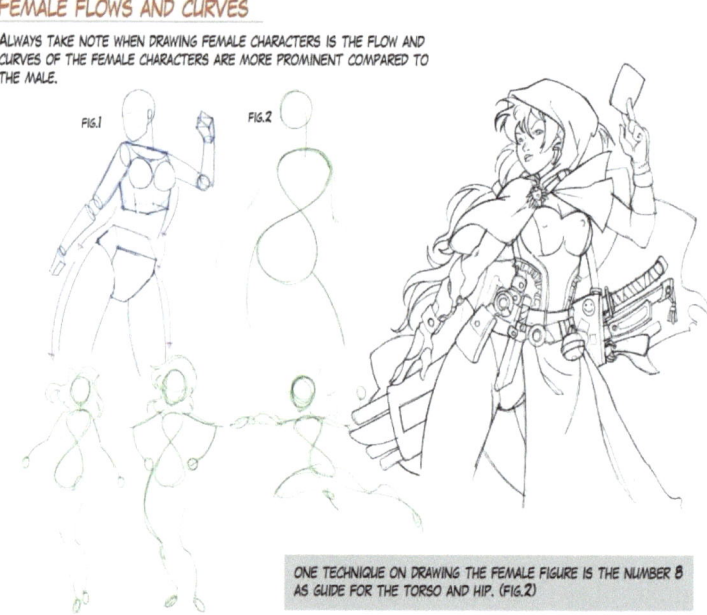

and their figures. Start replicating the shapes that you see in the women in your figure eight models. Practice this as often as you can, it's extremely simple and doesn't take up much time, but will help you spot the multiple shapes that women can be.

Differences

Now that you have a basic understanding of a women's figure, let's compare it to that of a man and we'll start with their basic shapes on the outside of the image. This will help you see the

basic construction differences before we move into the physical differences.

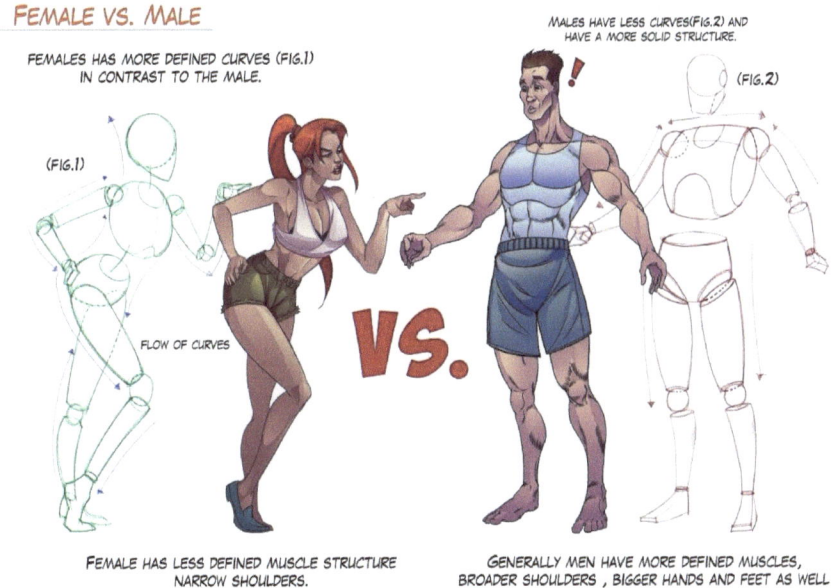

Let's start by looking at the woman's form in figure 1. The curves from the previous section are once again drawn out and showing you how the curves fall on the body in the pose that the woman is in. Notice how the figure is based around the simple shapes that we discussed in chapter one, with the woman having ovals for her center section to help you see the curves that she has. The curves from the body continue down the cylinders that make up the legs, following the shape that was already established.

In figure 2, you can see a man's figure and the general skeleton that goes underneath it. Notice how the man's figure is considerably blockier and is made up of squarer simple shapes, while the woman's had more curves to it. This means that the man

also has a blockier figure with almost no curves, as you can see by the man's waist which goes straight down. The legs and arms are made up of the same cylinders and spheres that the women's limbs are, but they're bigger, making them more proportional to his body.

When we look at the fully fleshed out figures, the differences that we discussed with figures 1 and 2 are emphasized. Also notice that the man has a muscular figure, his muscles show up considerably more than the woman's, whose figure is smoother and curvier. The man's head also shows how square a male figure can be, and how straight it can be, with the neck going up into the back of the skull. The woman's head maintains that soft curve the rest of her body has.

There are too many differences to really note between males and females. They walk differently and have different motions in general when they move. A simple drawing won't be able to capture everything that the genders do differently.

Exercise: Go and observe people in motion. See how women's curves move as women move. See how men's bodies move when they move. Note any differences that you see between the bodies of the genders that weren't mentioned in the previous section.

Drawing the Character

Starting by drawing a full body right off the bat is incredibly hard. You may also lose track of balancing and understanding some of the harder proportions of the human body that even experts struggle to master, like dividing up hands and feet or facial proportions. We're going to break things down to their simplest structures while working with a number of body parts that people tend to struggle with.

Proportions

Before starting on the smaller parts of the body, let's look at the actual proportions of the female figure. Some of the proportions that we'll be talking about can be applied to the male figure as well, especially the general arm and leg proportions. The torso proportions tend to be rather specific to the gender.

Body proportions can be complicated. Let's break it down and look at the stick person in figure 1. Figure 1 isn't a true stick figure, there are circles for the head, chest, and waist, but this is important to show the mass that these parts of the body carry. If you would like, you can replace the chest and waist circles with the figure eight that we discussed in the Body Structure chapter. The figure eight can show you where the shoulder joints are without needing to add the lines that you see in figure 1. Notice that the joints

of the figure are also circles, a return to our simple shapes and emphasizing where the joints are. In the arms, you can see that the elbow falls where the waist does on the figure and that the top and bottom potions of arms are equal to each other. The legs bow a little bit, showing the shape of the woman's legs and establishing their width. Like the arms, the top and bottom portions of the legs are the same length, even if it doesn't really appear that way.

The Female Body

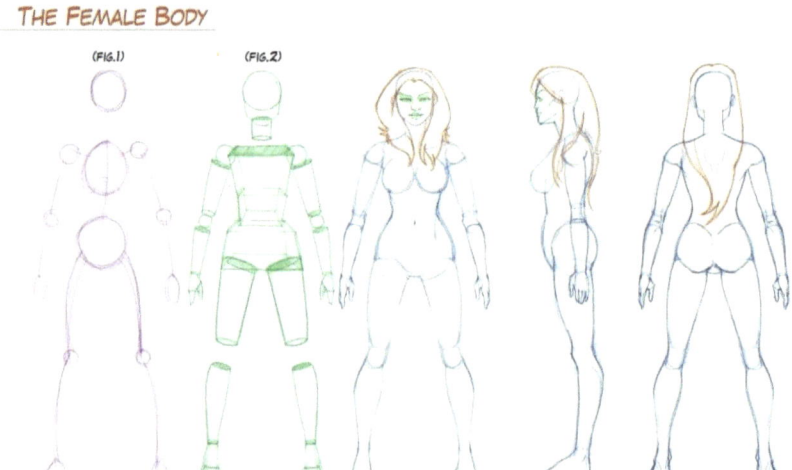

WHEN DRAWING A FEMALE FIGURE, ALWAYS THINK OF SIMPLIFYING THE FIGURE FIRST, LETS SAY A STICKMAN (FIG. 1) THEN ADD THE BASIC SHAPES LIKE CYLINDERS, CUBES, AND SPHERES (FIG.2). THIESE 2 STAGES APPLIES FOR THE MALE FIGURE AS WELL.

Let's return to simple shapes in figure 2. The shapes that we're using here tend to be more 3D as we work on making the female figure work in that dimension. In the torso, you can see that the circles making up the chest and waist have been replaced by cubes and rectangles and add a little bit more width to the body as the waist is adjusted to fit the width of two thighs. The arms and thighs are made up of cylinders that follow what the shape of the body would be with joints breaking them up. Notice that the

shoulder joints stick out from the actual body and don't fall into the shape of the cube their attached to. The cubes making up the upper portion of the torso decrease in size as they approach the waist while the square hips are wider and provide a sharp shelf for the hip to start on.

In the last three images on the right, you can see a smoothed out version of the woman from figure 2. Note how the hip comes in just above the shelf that existed, but there's a steep slope that gives the hip a smooth look. You can see the joint placements in all of the women, notice how the viewing position of the figure can change the appearance of the joint, like in the elbow and knee. The shoulder tends to maintain the same shape, but notice how the slope of the neck and shoulder smooth out over that joint. There are a number of other differences and similarities in the drawings, try and find ones that we didn't talk about.

Exercise: Practice drawing figures using the basic structures that we discussed with figure 2. Once you feel comfortable drawing the figures straight on, start putting your figures in various poses to see if you can maintain the proportions that you learned from practicing the figure straight on. This should be practiced on a regular basis, but it doesn't need to be practiced every day once you feel comfortable with it.

Hands

Understanding hands is hard. The palms themselves are easy to draw out, but when it comes to dividing fingers and giving them fair and realistic sizes? It can take a lot of practice to even come close to getting it right. Some great artists never really master hands and instead choose to use three fingers instead of the four that people actually have. That, however, is usually seen in cartoons.

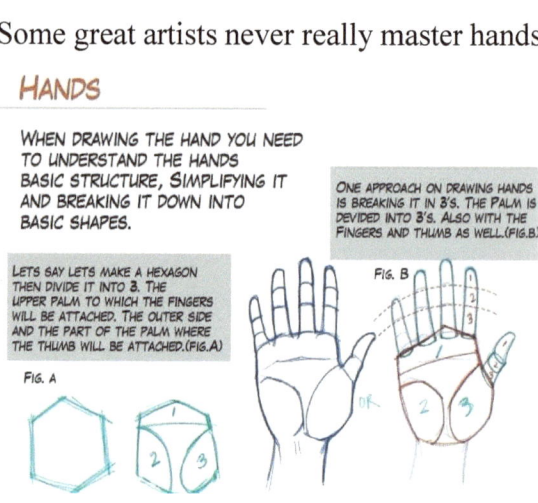

Knowing simple shapes is important when it comes to hands. A palm usually takes the shape of a hexagon, as you can see in figure A. The hexagon is then divided up into four pieces, but we only really care about the three major parts. Part 1 marks the part that connects the fingers to the palm, part 2 is the part of the palm far away from the thumb that takes the weight of the hand when you're writing, and the final part is the muscle that connects the thumb to the hand. Now, when the hexagon is turned into a hand, the lower points are smoothed out and connects the hand to the wrist.

There are two common methods that people use to divide up section number 1 on the palm for fingers. Figure B shows one method by using the Three's strategy, which basically means that

everything is divided threes. Three lines will divide the four fingers, two lines will divide the finger joins into threes, and the thumb will follow the same rule as the finger. Notice how the lines that divide the fingers horizontally for the joint follow the shape of the hand. When you look at your fingers you should see four joints that don't line up exactly with each other, they follow the shape you established for the palm.

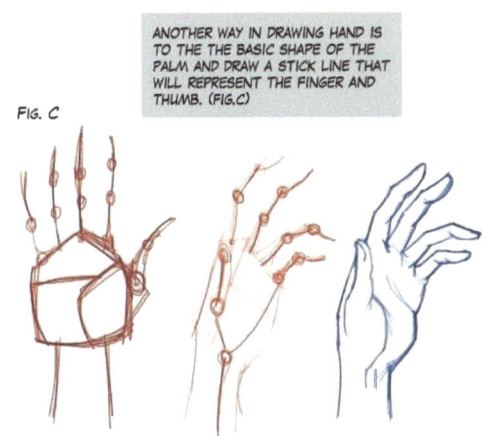

FIG. C

ANOTHER WAY IN DRAWING HAND IS TO THE THE BASIC SHAPE OF THE PALM AND DRAW A STICK LINE THAT WILL REPRESENT THE FINGER AND THUMB. (FIG.C)

The other method that people like to use can be found in figure C with the Skeleton method where you basically sketch out a rough skeleton using the simple shapes that we've been discussing. Circles make the joints while the fingers are made up from straight lines and the palm is divided into the sections we discussed with figure A. Divide part 1 of the hand into fourths so that you can find the fingers and then draw them out, making sure to realize that you're now marking the middle of the finger and not the sides, like you were with the Three's method.

Once again, we'll be returning to the chapter on Body Structures as we compare the hands between females, in figure D, and males, in figure E. Notice that the man's hand is considerably blockier than that of the female's, especially in the wrist area and around the fingers. The fingers in figure E are extremely thick and take up every single part of the hand without tapering while figure

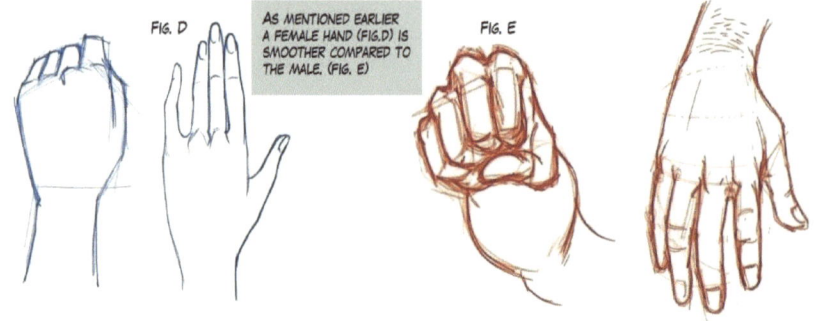

D's fingers are much smaller and taper from their hand connection to the end. Note that with the thumb joints, the man's has a very established joint while the woman's blends more into the hand itself.

Hands are just hard to get. Knowing where to divide the hand for fingers takes practice and a lot of erasing before settling on something that you're happy with. Knowing where to divide the fingers is considerably easier because you just follow the shape of the hand that was easy to establish because of the simple shapes that we keep returning to.

Exercise: Lay your hand flat on a piece of paper and trace it out. Mark out where the fingers are divided and where the joints fall. Now draw a hand based on what was just covered and off of the drawing that you just made. Experiment with the methods that were

taught and settle on something that works best for you, whether it be the Three's method, the Skeleton method, or a combination of the two. Once you feel comfortable drawing a hand flat, start experimenting with hands in different positions. See if you can maintain the proportions of the hand and fingers when the hand is sideways or when the hand is gripping something. Until you feel comfortable with hands, this should be practiced daily. Once you're confident, practice every other day or so.

Feet

Feet aren't quite as complicated as hands are, but they present their own challenges in drawing. Most people tend to struggle with the shape of feet, especially when they're in a not flat pose or supported by a high heeled shoe. Toes, like fingers, can also be difficult to divide, so we'll spend a little time dicussing that.

Like the hand, there are two ways to break a foot down into simple shapes that we'll then build up into actual feet. You can see the Cylinder method in figure 1, where the majority of the foot is made up by, drum roll please, a cylinder, which is marked in green. At either end of the cylinder there are two spheres, marked in blue. The heel sphere has an untouched form because the heel is made up from a circle, while the sphere for the toes has been flattened out and elonged with part of it chopped off where the sphere meets the cylinder. In each of the red feet surrounding figure one, you can see

still see the light markings of the shapes that we just discussed, see if you can find them. Another common way that people break feet down into simple shapes is by using the Wedge method, seen in figure 2. The shape of the foot, as seen in the red drawing under figure 2, shows exactly what the Wedge method is, which is simply imagining the foot as a wedge. The heel is a cube and the toes are a rectangle, they're connected by a rectangle between them. When you look at the blue drawing for figure 2, you can see that the wedge shape still needs to have circles for the toes and heel to make sure that the shape is maintained and that the foot doesn't turn out too boxy.

The bottom of the foot, seen in figure 3, can be made up of 2D simple shapes in the break down because most of the foot depth comes from shading. The toes, marked in orange, are five ovals of

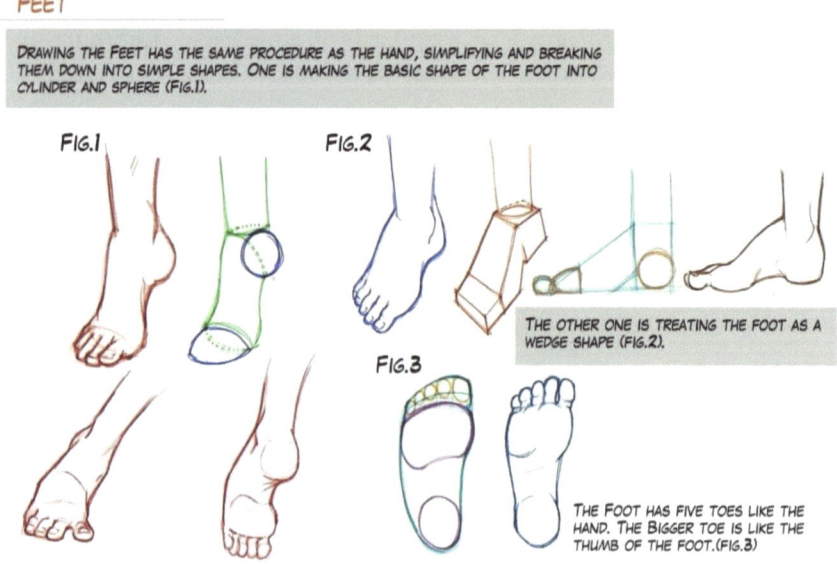

various sizes, with the biggest toe making up the largest oval and then the size decreases as the toes move down towards the edge of the foot. Three shapes make up the sole of the foot. An oval makes up the sole of the foot and a slightly misshapen circle makes up the front portion of the foot both of these shaped are marked in purple. Both parts of the sole are contained in a circle, marked with teal, that is similar in shape to the misshapen circle at the front of the foot. When you look at the fully fleshed out foot on the right hand side of figure 3, the shapes that we just discussed are still visible in the details of the foot.

Exercise: Practice drawing feet using the two methods that we discussed until you found the method of drawing feet that you're comfortable with and are comfortable with drawing them. Start putting the feet you're drawing in various positions to master the shape and proportions while you draw. Make sure to attach your feet to legs in order to make sure that your feet maintain the proper proportions to the leg and doesn't look either too long or too short when compared to the leg.

Heads

The most difficult part of drawing a head is getting the proportions of the face right and knowing how the face is really divided up. However, you can't get the proportions of a face right if you don't understand how a head is drawn.

Let's start by breaking down the two major portions of the face, using the images on the right as our example. Every head has two parts to it, the cranium ball, marked with orange, which makes up the back portion of the head and sits more on the neck. The facial plate, marked with green, is where the face actually

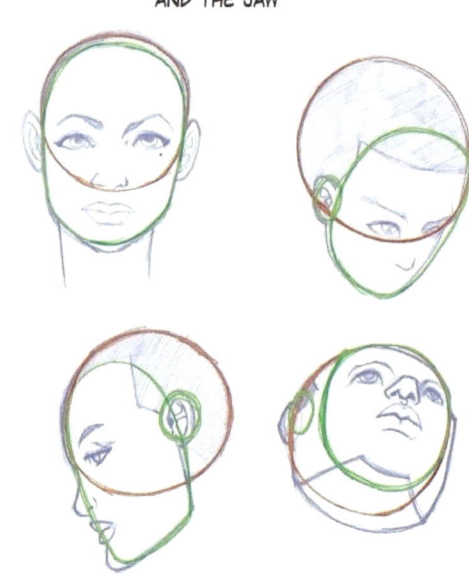

THE HEAD

THE HEAD IS COMPOSED OF TWO MAIN MASSES: THE CRANIUM BALL (ORANGE) THAT MAKES THE TOP AND BACK PART OF THE HEAD. AND THE FACIAL PLATE (GREEN) THAT FORMS THE FRONT AND THE JAW

sits and sits at the front of the cranium ball. The face itself doesn't actually show up on the cranium ball until you're about halfway down the ball, like the eyes are doing. The bottom of the nose falls at the bottom of the cranium ball, but remains on the facial plate. The mouth marks the halfway point between the bottom of the nose and the bottom of the jaw. On the side of the head, you can see the ears, note how they don't move above the brow line and in the side views, the bottom of the ear ends where the jaw begins. In each of the images, you can see a different angle of the face, notice how the only thing that changes on those faces is the perspective and not the actual proportions of the face.

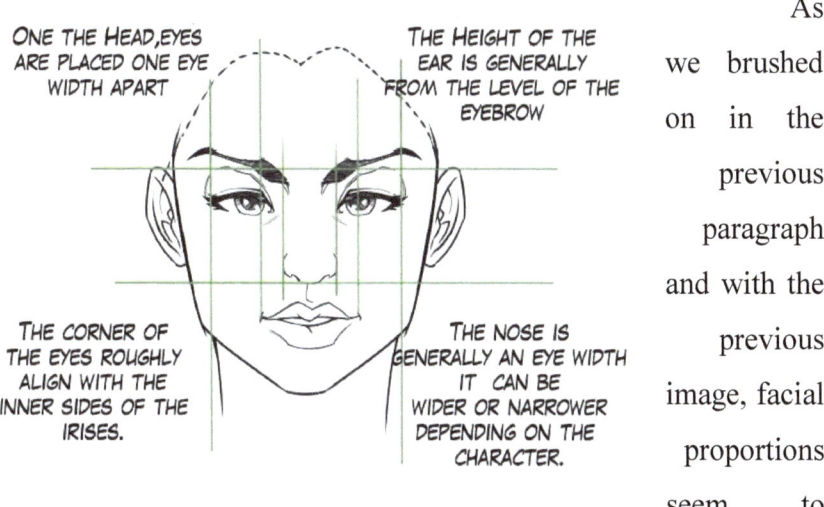

As we brushed on in the previous paragraph and with the previous image, facial proportions seem to change, depending on how the face is being seen by the viewer. However, a face tends to have pretty standard proportions, as you can see in the image to the left. As we covered, the eyes are at the center of the cranium, and the top of the ears don't go above the brow line, the bottom of the nose falls at the bottom of the cranium call, and the line of the mouth marks the halfway point between the bottom of the nose and the base of the chin. Now let's imagine a number of vertical lines running through the face to help us find the proper divisions. Start by thinking of four vertical lines evenly dividing the face, which will help you to find the center of the eye. Divide the face even further into eighths, you've now established the ends of the eyes. With the eye length known, you have the nose width. And when your eyes are looking straight ahead, like they are in our example, you will have the edges of the mouth.

We're going to briefly return again to the chapter on body structure as we take a closer look at the woman's head in the image on the right. Recall how we were discussing that the man's head is considerably blockier than that of the female's. You can see this in the image, especially in the right hand image with the steep curve that's running down the woman's neck, giving it the same type of curve that the rest of her body probably has. Notice how smooth the woman's face is and how there are curves in them, but they're toned down from what you find with the rest of the body. There are almost no harsh angles to define the characteristics of the woman, they're all soft.

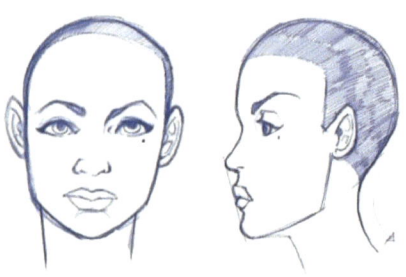
WOMEN HAVE A SOFTER LOOK BECAUSE OF THE BONE STRUCRURE TO BE LESS ANGULAR

Exercise: Draw cranium balls with face places in a variety of positions. Note how the face plate's shape can change with every position. Work with them until you feel comfortable and then start adding faces, making sure to practice the proportions that we discussed. Practice making your face the same on both sides, especially on the eye shapes which can be hard to master. Work on your faces every day, they're not easy to master and it will take a lot of time to happen.

Exercise: Go outside and observe people's faces. There are a

number of different eyes, noses, mouths, head, and ear shapes that dominate how a person looks and they come in a number of combinations. Note down combinations that interest you and then try to duplicate them in the faces that you're drawing or make up combinations and see if you like them. Pratice this at the same time as the previous exercise.

Expressions

Expressions convey emotions from one person to another when words may not be enough to express what a person is feeling. In a character, it can help bring them to life to the audience, but capturing the emotions that humans do instinctively and can catch in each other without practice can be difficult to translate into a character.

A common way for people to practice drawing expressions on faces is through an exercise called Shorthand Facial Expressions, which means that you use a small, cartoon like ball to exaggerate the emotions that people feel and show on their faces. When you look at the image below, you can see how the emotions are made to pop on the woman's face. Notice how the eyebrows are a really big part of expression of emotion. If the eyebrows were stuck in a static expression, the rest of the face trying to convey the emotion wouldn't have a big impact. With a body below the faces, you can

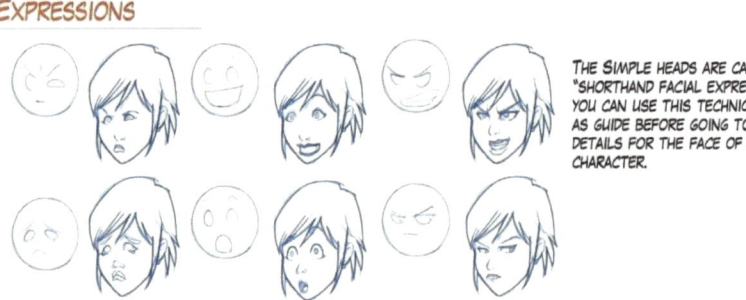

THE SIMPLE HEADS ARE CALLED "SHORTHAND FACIAL EXPRESSIONS" YOU CAN USE THIS TECHNIQUE AS GUIDE BEFORE GOING TO THE DETAILS FOR THE FACE OF YOUR CHARACTER.

add even more expression to the figure because body language will then be able to come into play, something that we'll discuss more in the Posing chapter.

The world around you can provide you with a number of resources for you to pull expressions from beyond the shorthand facial expressions. One fantastic resource would be the internet where you can explore web comics and web cartoons and see how other artists capture expressions on their characters and how it can be shown in various forms of animation. You can also look to your phone and use the various emoticons and emojis that are becoming more prevelant in our culture as inspiration for the emotions that you're looking to capture. Look at the characters in the image above and see what translates from the simple emoticons to the more complicated faces. Once again, take notice of the eyebrows in the pictures and observe how they help the emotions come across even more next to the text images.

Exercise: Sit down in front of a mirror and make faces at yourself. Explore how your face looks and reacts when you put yourself through various emotions. Capture yourself when you're at the

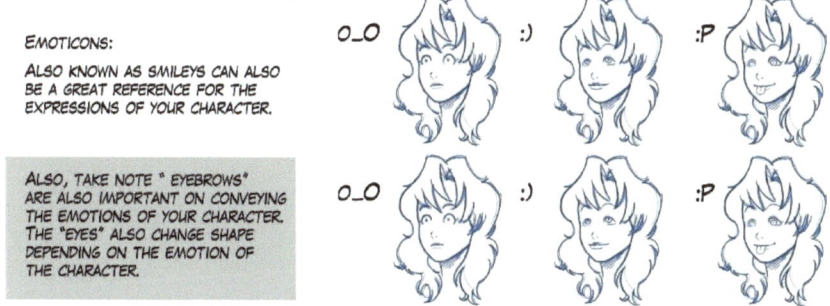

EMOTICONS:
ALSO KNOWN AS SMILEYS CAN ALSO BE A GREAT REFERENCE FOR THE EXPRESSIONS OF YOUR CHARACTER.

ALSO, TAKE NOTE * EYEBROWS* ARE ALSO IMPORTANT ON CONVEYING THE EMOTIONS OF YOUR CHARACTER. THE "EYES" ALSO CHANGE SHAPE DEPENDING ON THE EMOTION OF THE CHARACTER.

highest point of your emotion and draw it using an actual face or a shorthand facial expression. Work on a different emotion every day, it doesn't have to be for too long, just enough that you understand

what an expression can do to your face. Once you feel as though your have the basics down of the emotion, start exploring it in depth and work on one particular part of the face to understand what the emotion does to that one part of you.

Exercise: Sit down with your friends or with a movie. Work on noticing the differences and similarities between the same emotions on different people. Try and see if there's something about the peoples' faces that gives them the differences in the expression. What's the same about it? Try and capture the differences using faces or the shorthand facial expression method. You don't need to physically practice this every day, but you should take the time daily to observe people in some fashion until it becomes a habit.

Posing

When you pose a character, you give the figure a way to express themselves on a static page. Defining a character's pose gives them definition in the world. With the pose, you're explaining to the audience what they're doing and how they're feeling about it because of the body language that becomes visible. When you combine the potential of the body with the facial expressions that we discussed in the previous chapter, you can clarify what your character is doing or express the conflicting emotions that they're feeling.

Foreshortening

Foreshortening is a way of adding depth to a character or to an object. By making part of the object appear closer to the viewer and having the rest fade into the background, it adds a very slight 3D effect. Everything that we've talked about so far still applies to this idea.

For example, let's start with the cylinder in the left column of the image below. Notice how in the top image, where the cylinder is lying on its side and straight to the viewer, that neither end appears closer to the viewer. When you move down one image however, you can see the cylinder starting to rotate towards the viewer and you're beginning to get a sense of depth as the right portion of the cylinder takes up most of the foreground (the front section of a drawing) and the rest of it fades into the background, but is still visible. In the final

two images you get the tunnel effect from how one side of the cylinder is in the foreground and you can see through to the back of the cylinder as it moves by you. The back of the cylinder is very far into the background and parts of it disappear because of the view that we're given.

As we've been covering throughout the book, a figure made of simple shapes is easier to draw and then be turned into a fully fleshed out figure. You can see this in the two images in the middle of the image with the simpler figure in red and the fleshed out one in green. Note how the character's right hand is in the foreground and immediately claims your attention before you look at the rest of the image. The cylinders that make up the arm and legs show how the rest of the body fades into the background and that is kind of hidden in the green drawing, especially in the arm because of how it's structured. Notice how the lower leg cylinders is one of the smallest parts of the body, but it's still proportionally correct. The right foot is almost invisible because of its placement, but it still works with the body and is the right proportion, especially when you look at the left foot.

When you look at the fully fleshed out figure on the right hand side of the image, you can see everything that's we've already discussed. The character's right foot is the most prominent feature of the character as it is in the foreground as everything else fades into the background, especially the left elbow as it is the farthest point from the foot. This may seem like an extreme example of foreshortening, but this idea needs to be kept in mind whenever you

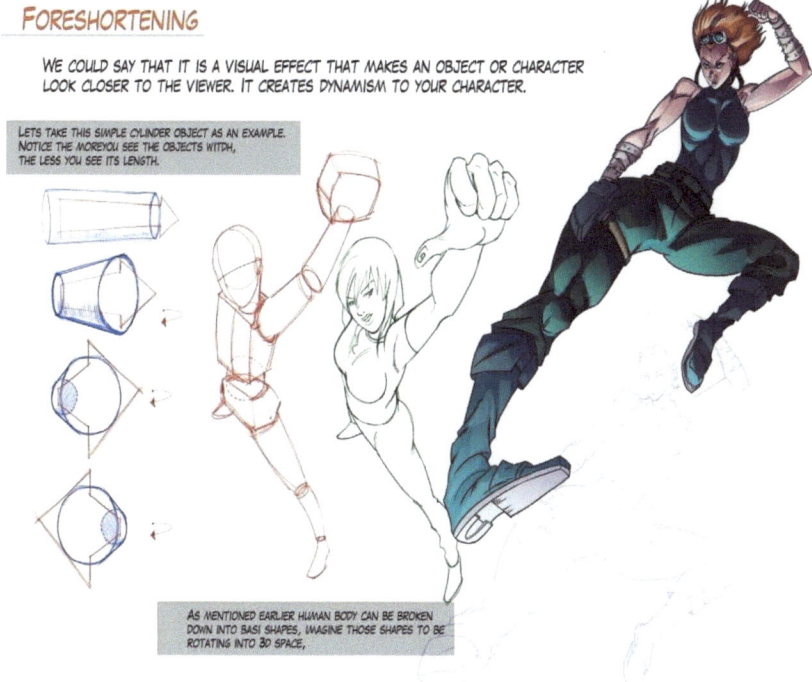

draw a character because it gives the character depth and shows the general positioning of the character in a world, even if they're the only thing in it.

Exercise: Find images and pictures of your favorite characters or celebrities online. Look for pictures that are good examples of

foreshortening. Once you've found some images that you like, start dividing them up. Look for the part of the image that makes up the foreground and then try to find the part of the image that's farthest back from the viewer. Then, try to find where the middle portion of the image is. Do this on a number of images and practice it weekly. All you're trying to do with this exercise is develop the instincts that you need to create images with a realistic amount of depth while maintaining the correct proportions of a body.

Exercise: While you work on developing your instincts, start practicing by making simple shape drawings with portions of the body in the foreground. If you'd like, take poses that you found in images from the previous exercise and work on duplicating them with your figures before trying to do it on your own.

Poses

Foreshortening happens when you pose a character and decide what they're trying to do with their body and who they're addressing it to. But you can't have foreshortening without a pose and a defined center line for the character to cross. A posed character however, doesn't have to move towards the viewer at all, it can stay on the 2D plane while still conveying the emotions that a figure trying to move into the 3D plane would.

When establish a pose for a character to stand in, image a center line, like a human spine, running through the entire character from their head to their butt, like the two simple shape drawings

marked in blue that you see in the left hand column of the image. The figure in pink on the right side of the image is posed. Next to her, in green, you can see what her spine looks like in order to create the pose, although the spine itself is a little enlarged so that you can see the shape better and without the inference of the rest of the body. Notice how the movement still seems comfortable for the character and natural in regards to the human body. Look at the figure in blue, the motion is still natural and the line going down the spine is easier to spot. In figure 1, you have an idea of what the spine is trying to look like, just at a different angle because it would be hard to spot if we kept it at the same angle.

Exercise: Find some heavily posed characters from either the rest of the book or the internet. Look for the spine in the characters and mark where they begin and end. Note how the spine and the motion

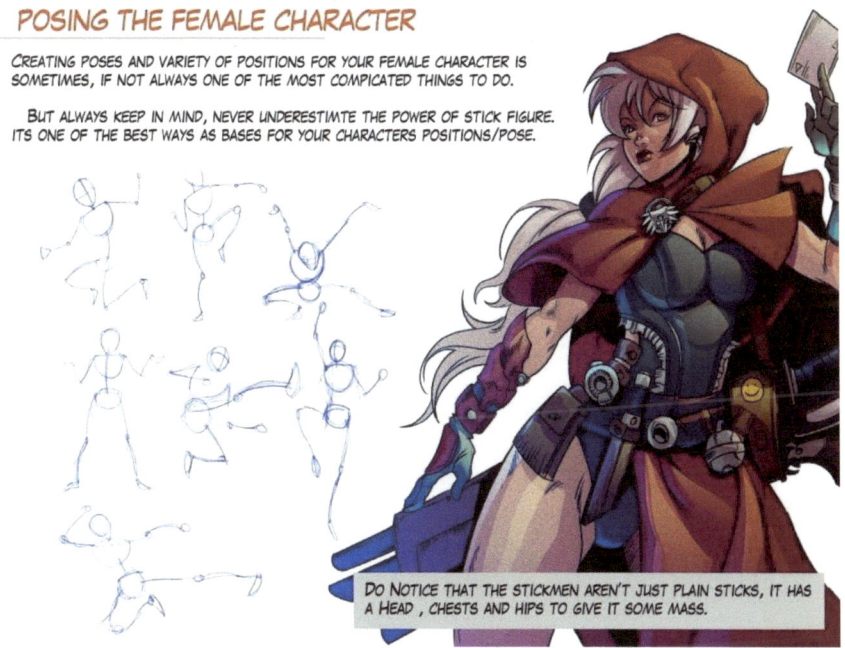

POSING THE FEMALE CHARACTER

CREATING POSES AND VARIETY OF POSITIONS FOR YOUR FEMALE CHARACTER IS SOMETIMES, IF NOT ALWAYS ONE OF THE MOST COMPLICATED THINGS TO DO.

BUT ALWAYS KEEP IN MIND, NEVER UNDERESTIMATE THE POWER OF STICK FIGURE. ITS ONE OF THE BEST WAYS AS BASES FOR YOUR CHARACTERS POSITIONS/POSE.

DO NOTICE THAT THE STICKMEN AREN'T JUST PLAIN STICKS, IT HAS A HEAD, CHESTS AND HIPS TO GIVE IT SOME MASS.

that it causes seems to influence the entire motion of the body. Spend some time practicing finding the spine, you just want the ability to spot it immediately and then put it into your own figures.

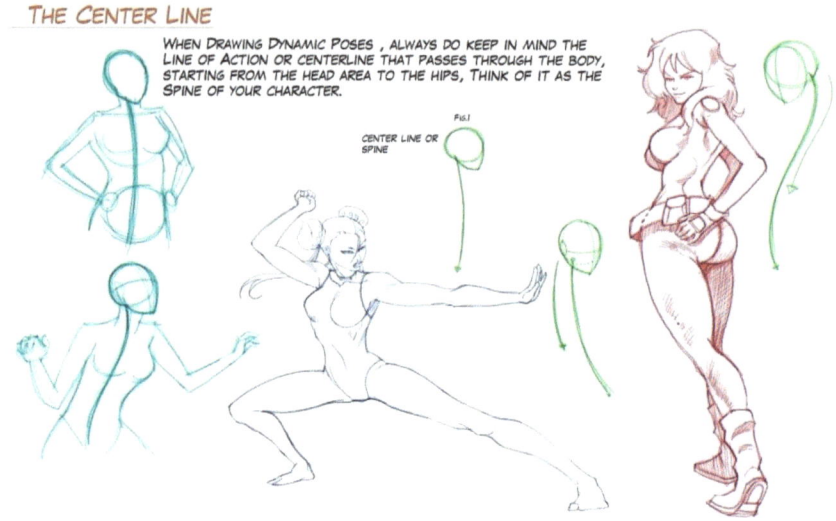

We've now discussed the spine of characters and how foreshortening works to give characters depth, so let's discuss some of the poses in the image above. Notice how all of the drawings on the left hand side are stick figures with heads, chests, and hips. This helps establish mass and to help give you realistic proportions for your characters when you feel ready to put more flesh on them while helping you to establish the center line on the character and the foreground. Knowing where the foreground is will help you to figure out how to foreshorten the character without throwing off the proportions of the character. Stick characters are fast and easy to create while also giving you a rough skeleton to build off of, which is invaluable.

Adding Clothes

You have a character. She has a role in the world that you're creating and it needs to be established. Somehow. One big way to do that is through the clothes that she wears. It helps define her personality and define how she likes to dress when she's relaxing, at the gym, at work, at church, or running errands on a Saturday. If they're in an army, do research to know the insignias that exist, what they mean, and where they go. Remember, every piece of clothing fits differently on a person. Take a look at the center orange figure in a school girl uniform. The socks are form fitting around the calf while the skirt flows around the legs, giving no defining features to the thighs or to the hips. On the upper half of her body, the shirt shows off the woman's figure, but it doesn't hug her as tightly as the socks do.

In the green figure on the right, the jacket and shirt on the upper half of the woman are loose and don't really show her figure

DRESSING UP YOUR CHARACTER
AS FOR DRESSING UP YOUR CHARACTER, RESEARCH IS ALWAYS THE KEY ON MAKING UP A CONVINCING COSTUMES/DRESS FOR YOUR CHARACTER.

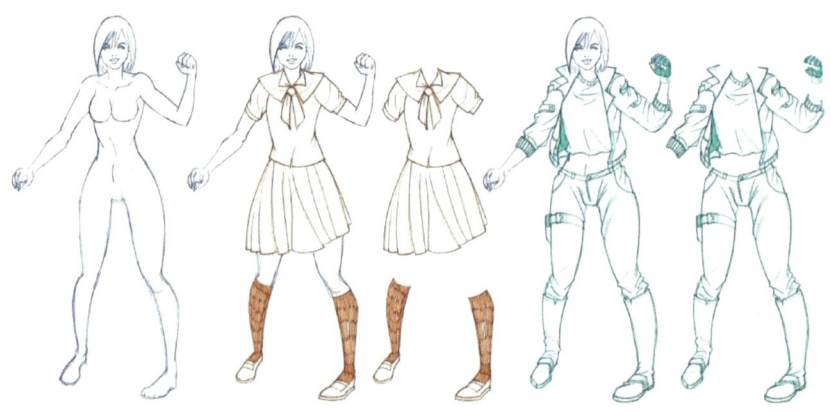

DONT HESITATE TO USE REFERENCES FOR THE COSTUME/ ACCESSORIES FOR YOUR CHARACTER. YOU CAN USE FASHION MAGAZINES OR MAYBE HISTORICAL BOOKS FOR ARMORS AND OTHER STUFFS.

except in a broad and nonspecific way. The shirt is a crop top and ends at the woman's waist, giving a small view of her tummy before the tight pants begin. Notice how the pants show crinkles in at the joints, where the body has a lot of movement, like at the hips and at the knees above the tall boots.

On the left side of the image above, we have a basic female figure in her nude form to show the basis of the character that we just examined the clothes of. Each set of clothing makes her seem like a different character. The school girl's outfit makes her seem young and prepared to go to school, maybe getting ready for a fight in the school yard against another classmate. However, when we see the woman dressed in the jacket and pants, she seems older and

prepared to fight against something bigger than herself or a criminal. She looks like she belongs on the street and can take care of herself.

Know your character when you dress them. If you're lost for ideas, look at fashion magazines or shows to see what's trending, look outside and see what everyday women are wearing. If your woman falls into a historical era, go and research common fashions for the time. Even fantasy worlds have guidelines for what characters wear, depending on who they are in a party. When you look into these clothes, take a closer look at the movement of the clothes and how they hung on the body so that you know how they should react when you pose the character and you're trying to show the movement, or lack thereof, that the character has.

Exercise: Create a character. Draw them and work with them. But then go into their back story. Spend time with the character to understand the world they're in and the role that they play and how this influences their wardrobe. Research the clothes that they would wear and start drawing the clothes without the figure in them. Once you're comfortable drawing the clothes without a figure inside of them, start putting your character inside of them in a number of different poses so that you can explore the motion that the clothes give to the figure when they're moving. This doesn't have to be done on a daily basis, but it will need to be practiced, maybe once or twice a week so that you can practice manipulating the imaginary fabric to show motion.

Inking and Coloring

Once you feel like you're ready to begin really bringing your character to life, there are a number of options for you to explore. The ones that we'll be focusing on today are inking and coloring.

Inking

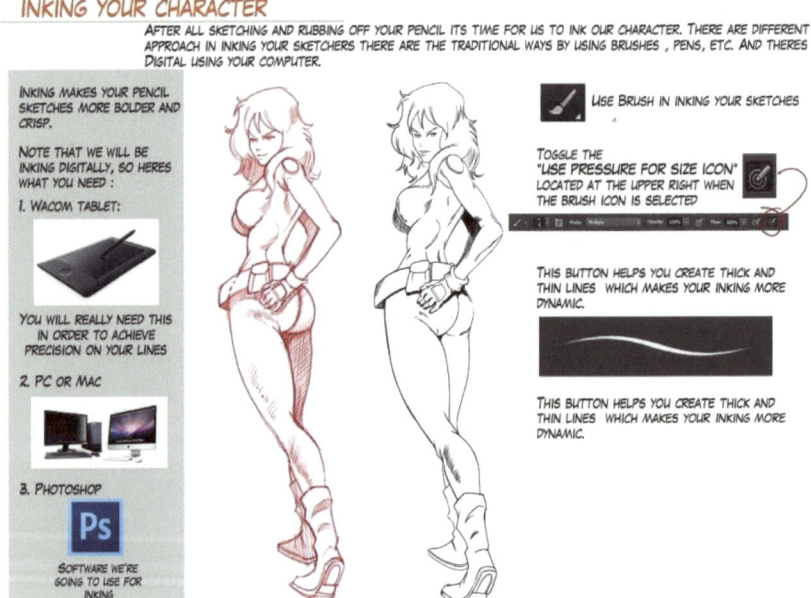

Inking is a way to make your character have bold lines that are crisp and can bring out the details in a character that could be hard to see. There are multiple ways that this can be done, both in the real world, through pens, markers, paint, etc., and digitally through a variety of programs, like Adobe Photoshop or Gimp. Some people, when they ink digitally, like using tablets designed for artists because they find that it gives them better control when they're going over line and can help them use pressure to give a

dynamic look to the character and change how various lines are defined.

When you look at the red image on the left hand side, you can see an image with no inking, the lines to define the character are there, but they can be hard to see. In the right hand image, you can see one that's been inked. Her outer lines are more defined and the shading lines don't need to be so plentiful because the shading lines can be darker and closer together, defining the curves, like those in the character's boots and on her leg.

Exercise: Take one of the drawings that you created or practiced on from a previous example and copy it, if you would like. Decide how you would like to ink the character and begin practicing until you feel comfortable with your skill level. Now, inking a character isn't a mandatory step in the process, so practicing can be light or heavy, depending on how skilled you'd like to feel in the art form.

Coloring

Adding colors to a character can help define shape, muscles, poses and foreshowing even more than inking can. It helps add in another element. This can also be done in a multitude of mediums, including paint, crayons, colored pencils, markers, Adobe

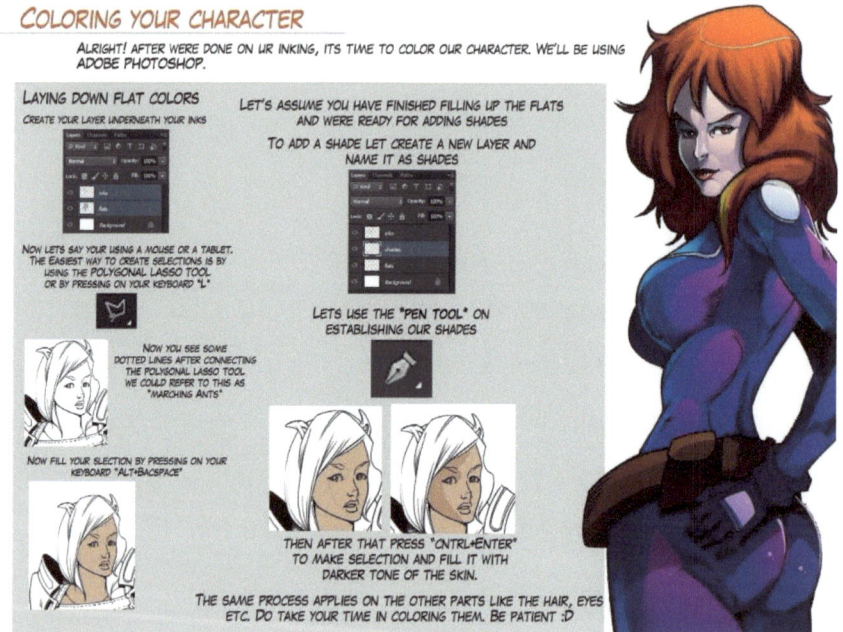

Photoshop, Gimp, or any combination of those elements. If you look at the image, you'll find a walkthrough for Adobe Photoshop for people who are interested in digital coloring.

If you look at the image on the right hand side of the image, you'll see image that we were discussing during the inking section of this chapter, now fully colored. Where the color is lightest, you can find the part of the figure that is closest to the light. There's a slight halo of light around the woman's head, while the upper

portions of the muscles and arm show light portions of their respective color. When the color goes down a shade, you can see the beginnings of a shadow and when the color goes down another shade, you get one of the darker portions of the body. When there is black, like on the far breast, there is no light hitting it and you know that the light is coming from behind the woman. The shadow from the arm pointed closest to the viewer has a shadow going down and a little to the left, so we know that the light is mostly above her but a little ways behind her.

In order for an image to have depth, there doesn't actually have to be color, you can simply use shadows to define characteristics of your female figure and the light placement. Or you can use black and white. The drawing is yours to do what you like with. You're the artist, you get to decide.

Exercise: Take the character that you decided to practice your inking with and scan it into your computer or copy of it if you want to physically color it in. Go to town on your coloring, using whatever colors you want to practice with. This exercise isn't mandatory, but it is a good idea to practice your depth and shading, even if it's only a black and white image. That black and white image will still have a number of shades of grey to denoted shadows, which will add depth. Practice however much you want to, but once a week is recommended, even if it's only on one of your practice examples images.

Conclusion

Congratulations. You now have the skills to draw a basic female character. You know how to break down a complex character, how to draw her face, hands, feet, and basic proportions. You know how to put emotions on a face and then position her body to emphasize that emotion. You know how to dress her and then how to bring your character to life through inking and coloring her in however you want.

The skills that you've learned are transferable to other parts of the drawing world. Breaking complex things down isn't something that you can just use for characters, you can use it for cars, buses, planes, or a fish, among other things. Knowing general positions and understanding how to put a rough skeleton together to practice positions with can help you with men, women, and animals. Everything in this book is transferable to something else within the drawing world.

However, in order to really understand it, you need to practice your drawing and what we covered, in the real world through the exercises that were provided. Reading a book on drawing female figures won't magically make you the best person ever, you have to practice what was taught. And then, if you want a more realistic figure of a woman, you have to go out and observe woman moving in daily life. Try to capture that on paper either with

the skeletons or with a figure. Try to capture a figure in motion and how their clothes move around them.

And most of all, remember that women come in all shapes and sizes. There's no concrete form for a woman or for a man. Some women have male characteristics and some men have female characteristics. Everything that was provided in here was a generalization on a female form to help you understand how a majority of women move.

Now, if you look below, you'll see a compilation of images that we discussed at some point during the book. Go through them and see if you can figure out where everything that we talked about in the book comes to life in them, especially if they're a full body image. See if you can find the simple shapes that make up the figures and then where the light source comes from for the character. Explain to yourself why you think that that's where the light source

is. Notice how the clothes move around or on the character and try to replicate the movement of the clothes.

Characters

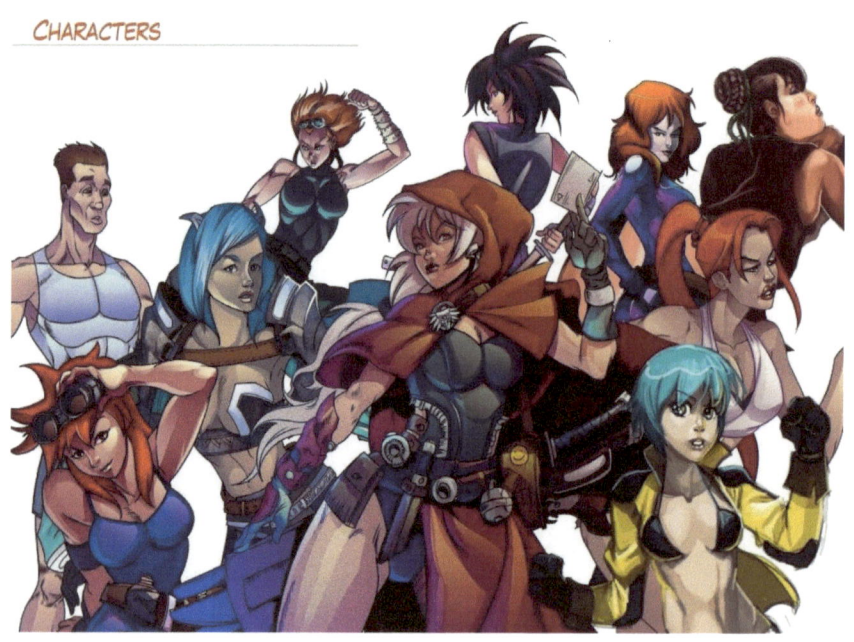

www.ingramcontent.com/pod-product-compliance
Lightning Source LLC
Chambersburg PA
CBHW041206180526
45172CB00006B/1205